LOULOU THE PUG

LOULOU THE PUG

A Book by
MeetThePugs

hardie grant books

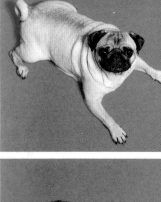
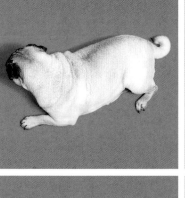
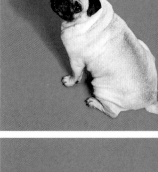
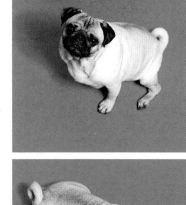

MEET
THE
PUGS

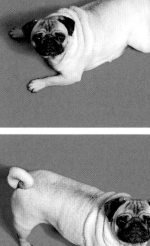
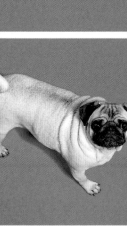
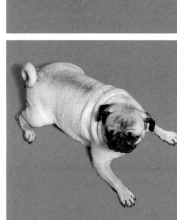
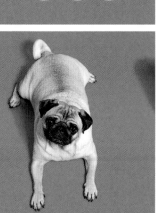

CONTENTS

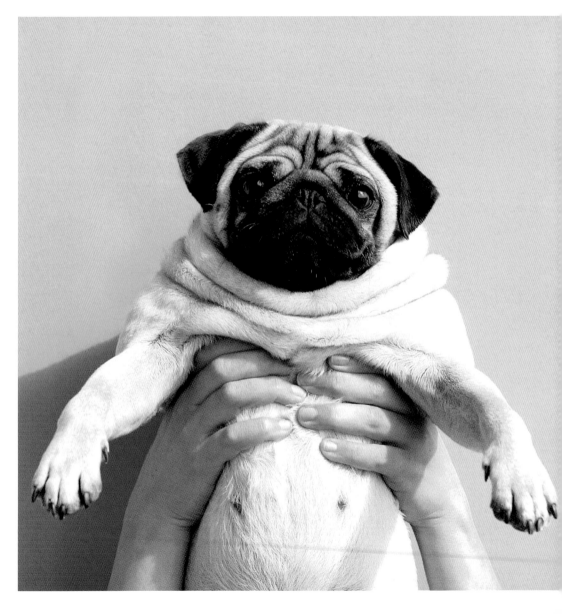

INTRODUCTION

An ode to squishy-faced puglife.

If one dog symbolises cuteness, it has to be the pug. With its wrinkly face, big round eyes and curly tail, the pug is a real-life teddy bear. As soon as you see it, you instantly want to cuddle.

Only pug-lovers can confirm: **THIS BREED IS HIGHLY ADDICTIVE!**

Loulou has already charmed thousands of people on social media and will now make your life better with close to 100 surprising, utterly awesome images and hilarious quotes.

Throughout the pages of this book you will get to know Loulou as a fashion queen, culinary expert, zen master and much more. One thing's for sure, you will not get bored!

Oh my pug!

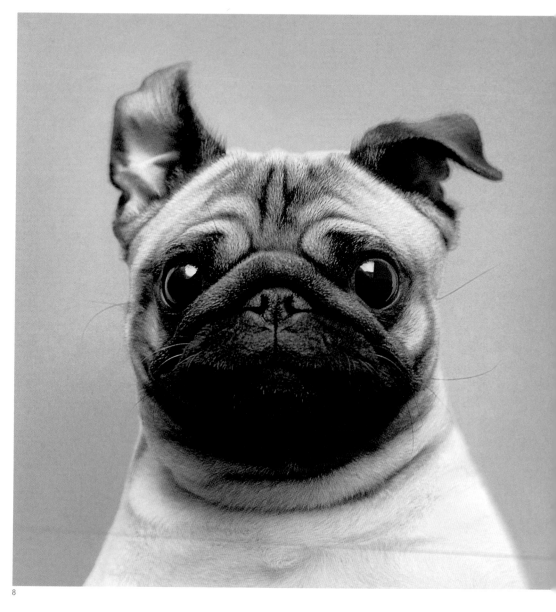

Chapter 1

UPS & DOWNS

Pugs have feelings too, you know.

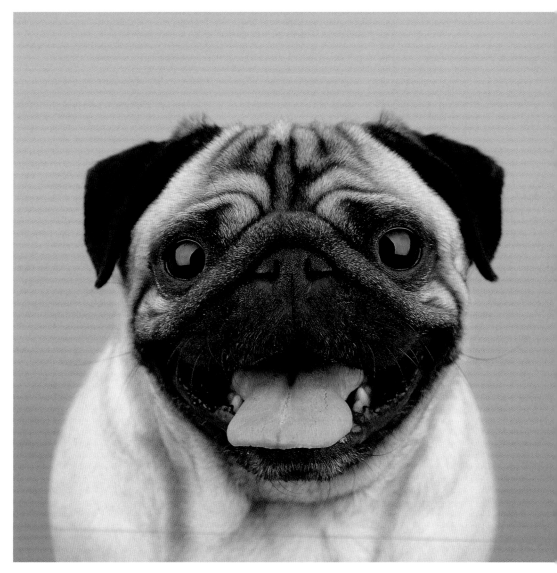

"Whatever you're saying, the answer is yes."

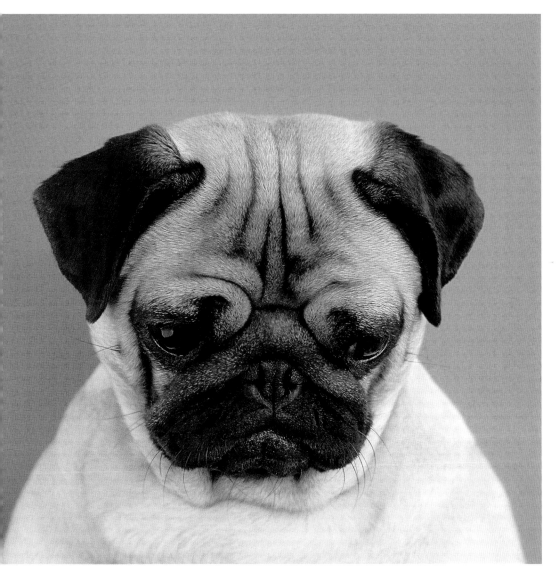

"What do you mean I'm adopted?"

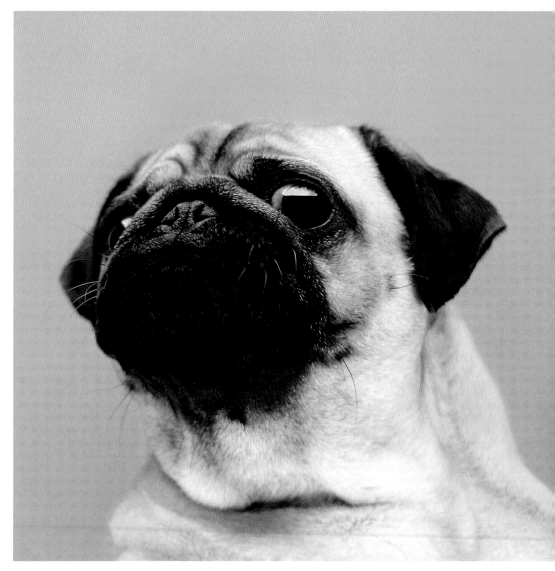

"You talkin' to me?!"

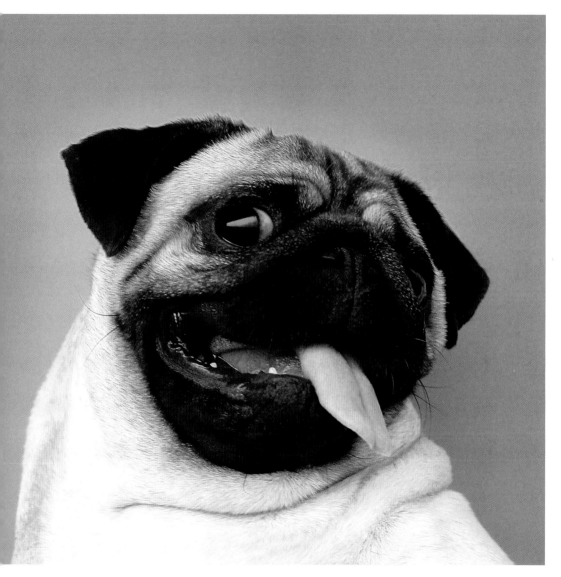

"This is my crazy face."

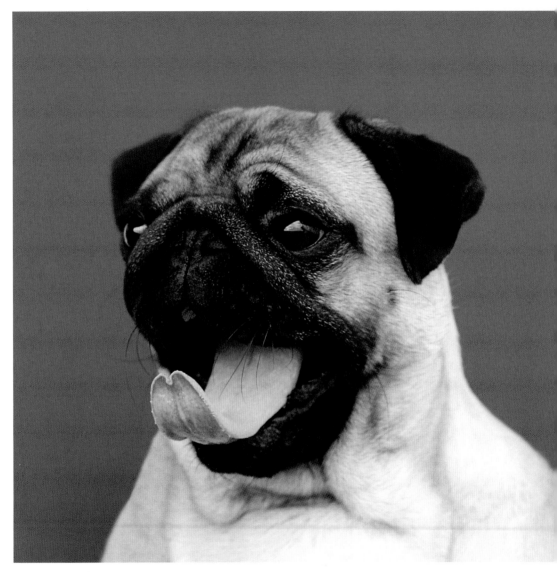

"Maaaaa! The sausages!"

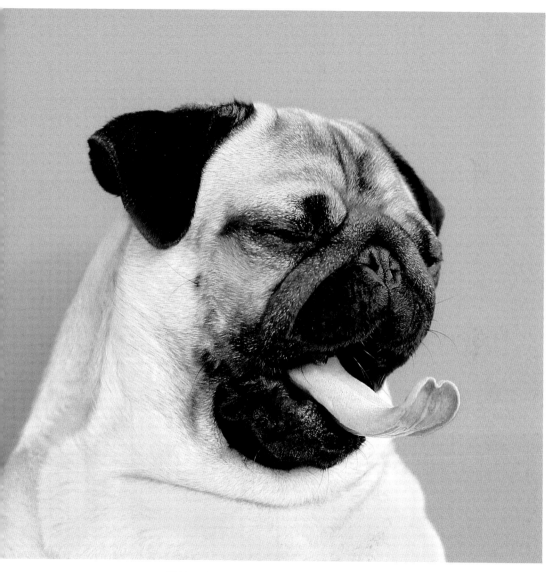

"Did nothing all day; I'm so exhausted."

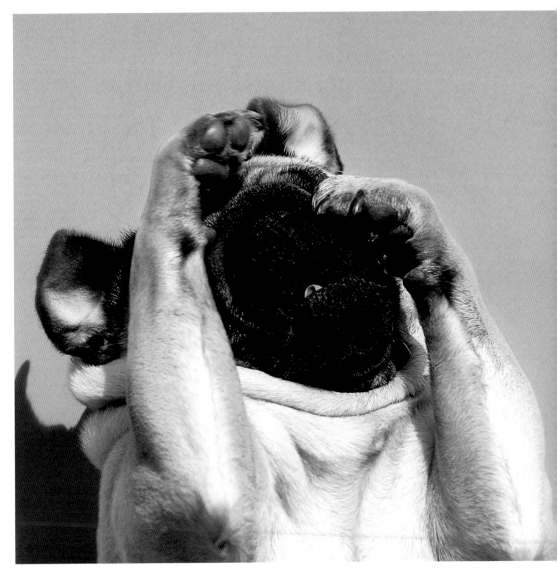

"No more bacon? What have you done?!"

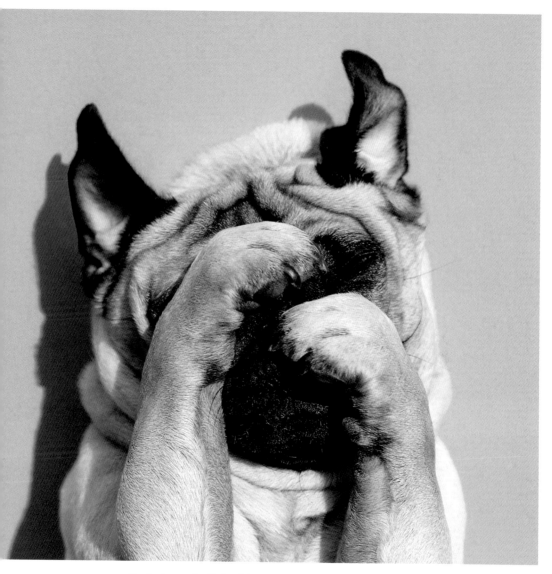

"Is that you, God? Or did someone turn the light on?"

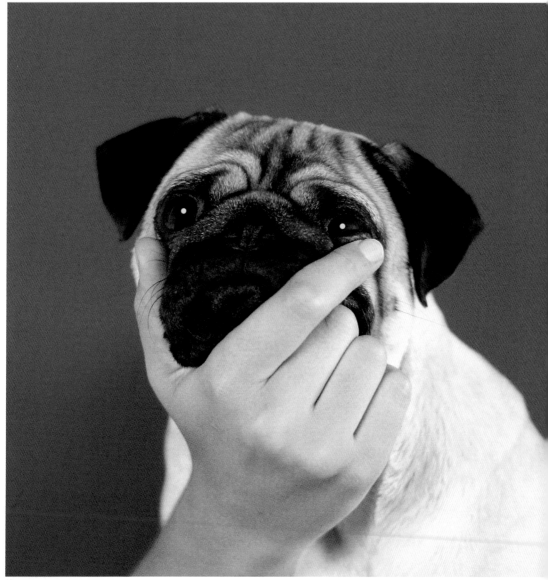

Chapter 2
TALK TO THE HAND

Cause my face ain't listening.

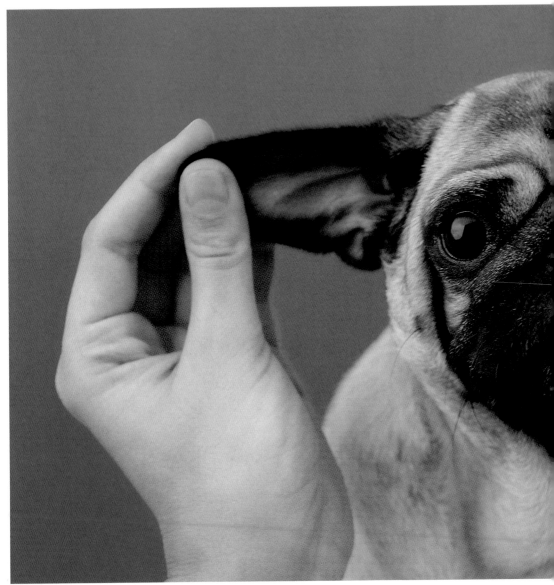

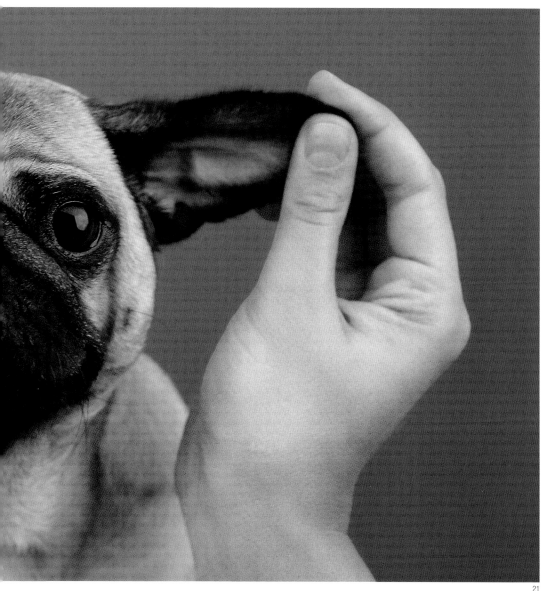

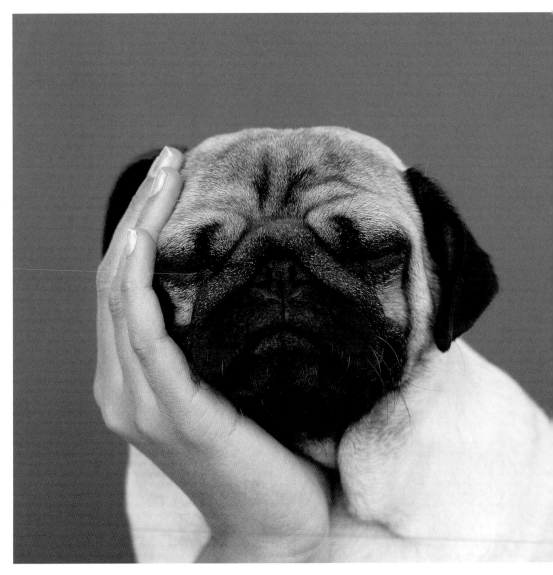

"Tired I am; sleep I must."

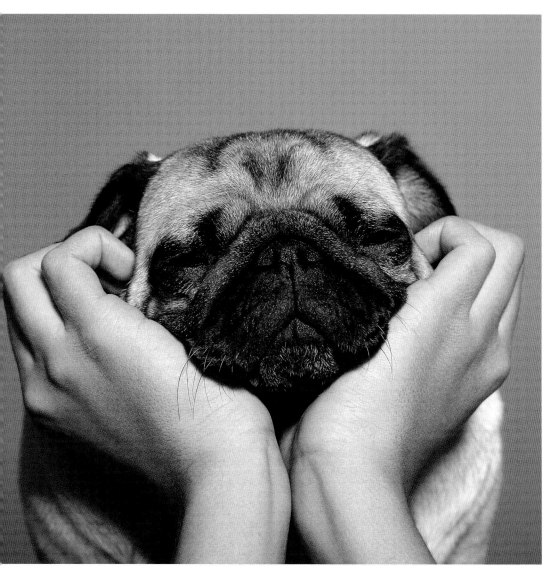

"Not sure if the class is boring or I'm just really sleepy."

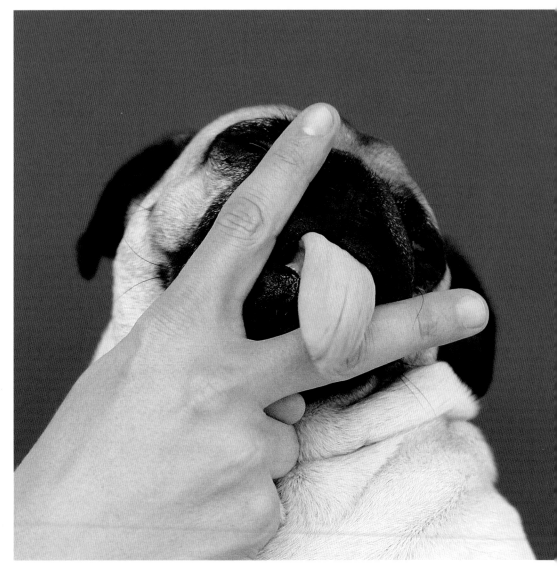

"Leaving work on Friday like…"

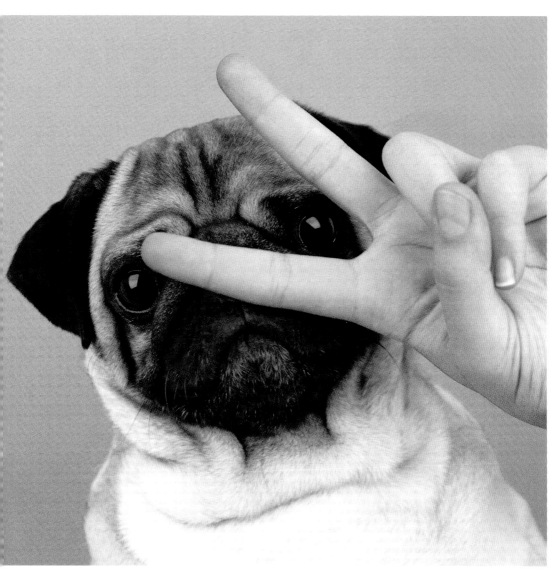

"I come in peace."

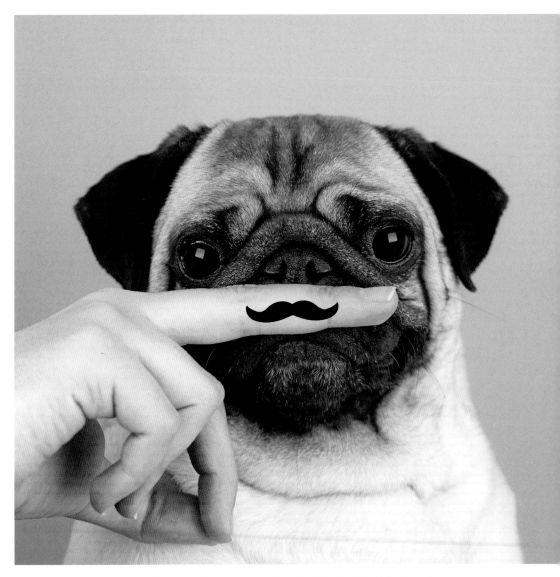

"I moustache you a question, but I'm shaving it for later."

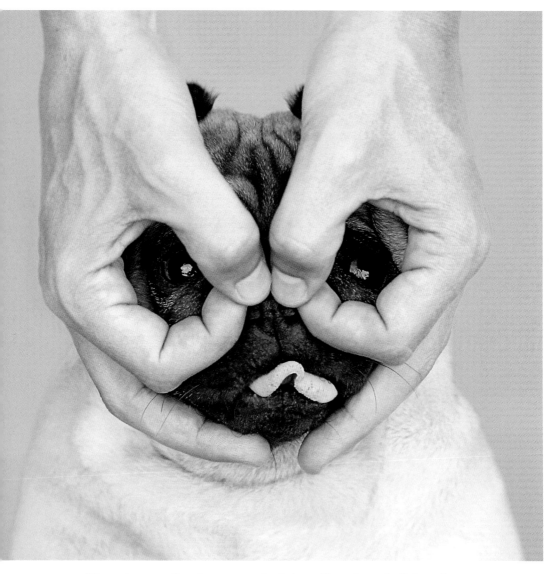

"Always be yourself, unless you can be Batman. Then always be Batman."

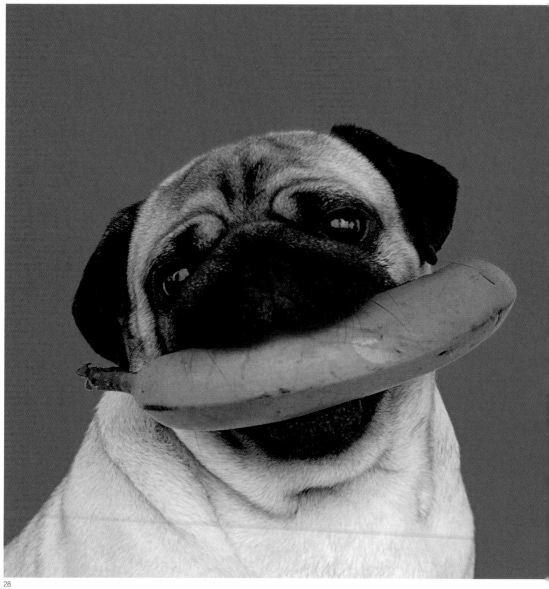

Chapter 3
<u>TUTTI FRUTTI</u>

Life is like a fruit salad – sometimes peachy, sometimes bananas.

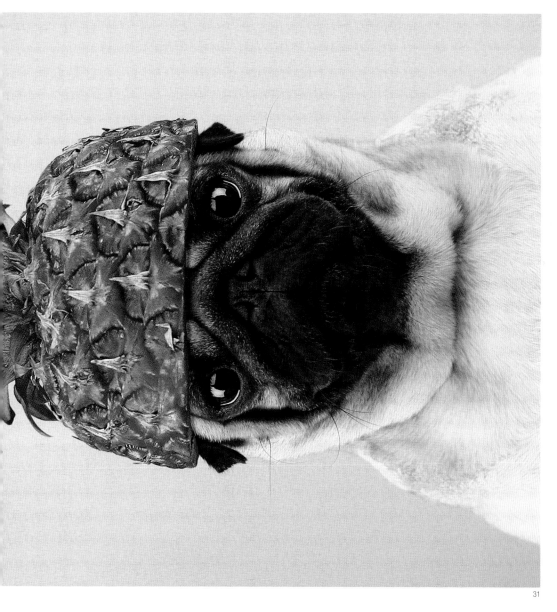

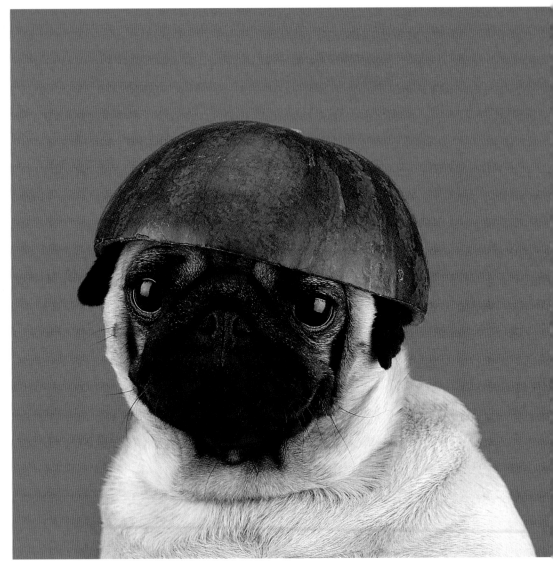

"Safety first!"

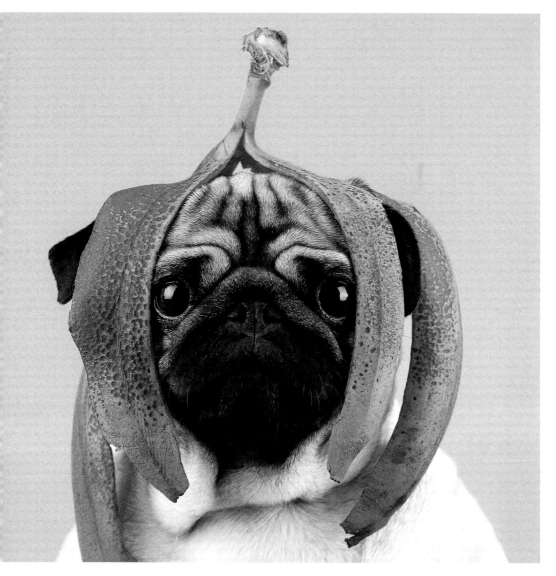

"Do you find me apeeling?"

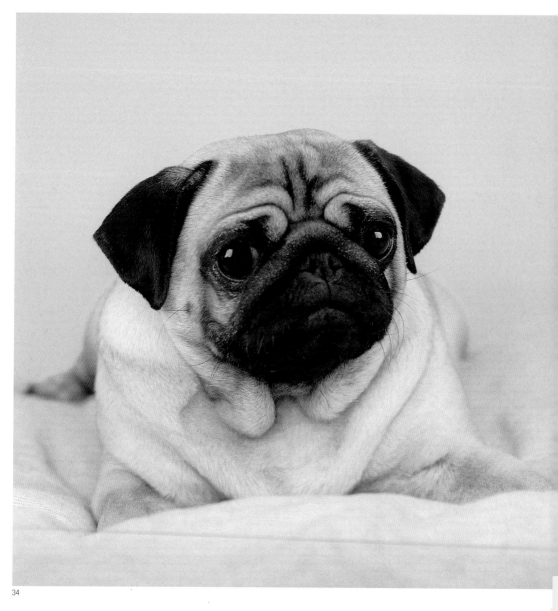

Chapter 4
BEDTIME STORIES

Sleep tight and don't let the bed pugs bite.

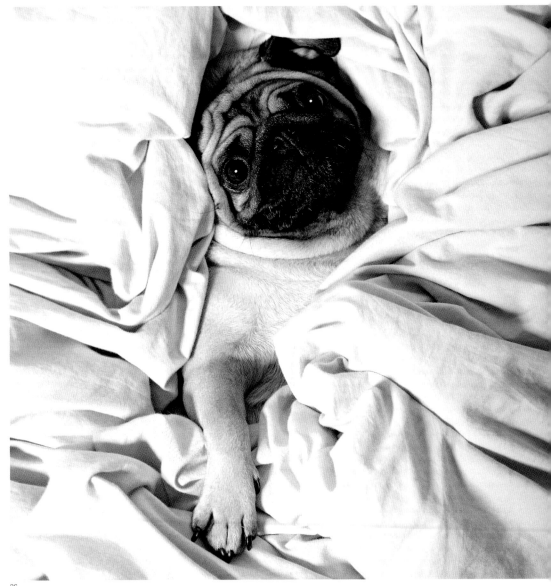

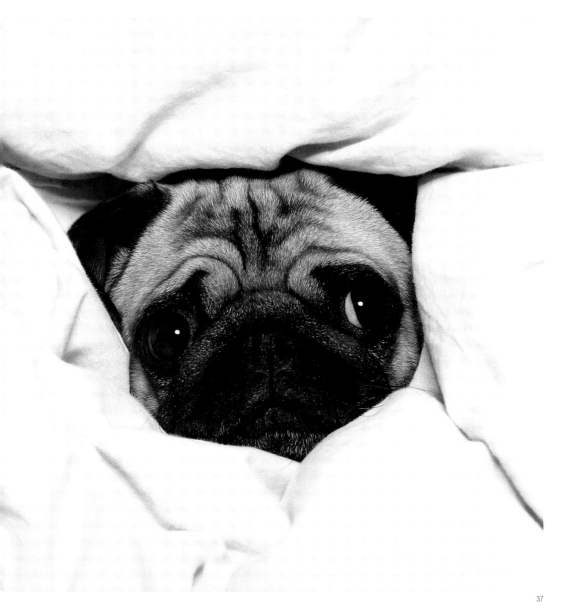

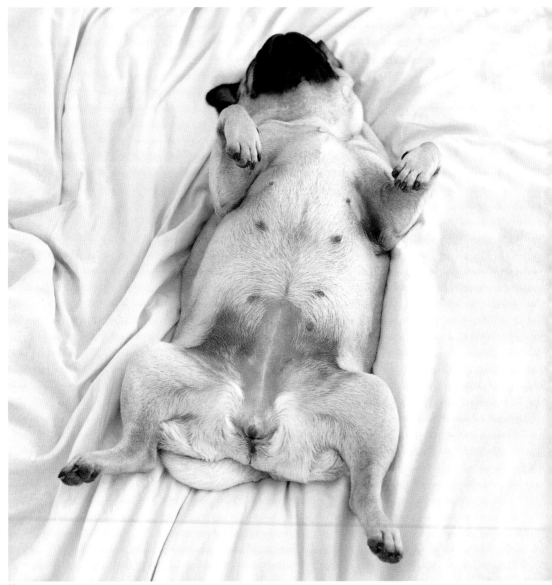

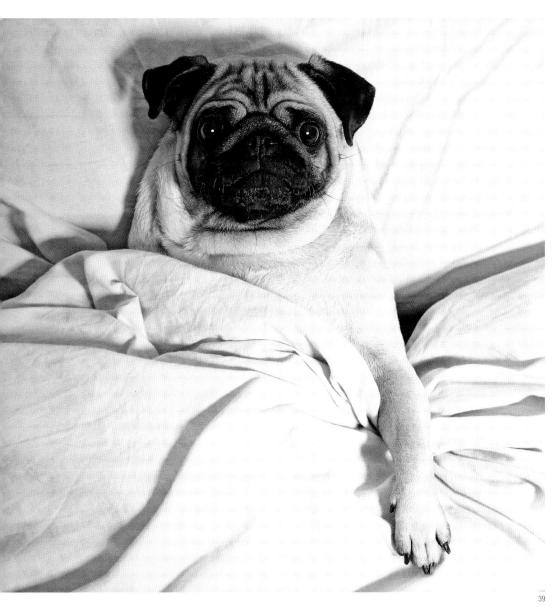

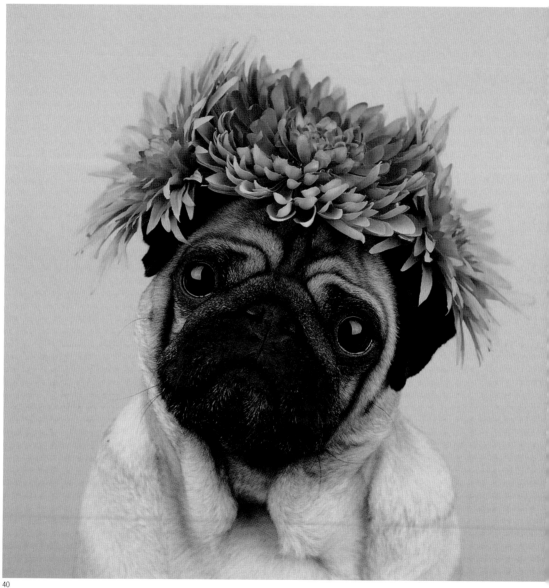

Chapter 5

FLOWER POWER

Feel the flower, be the flower.

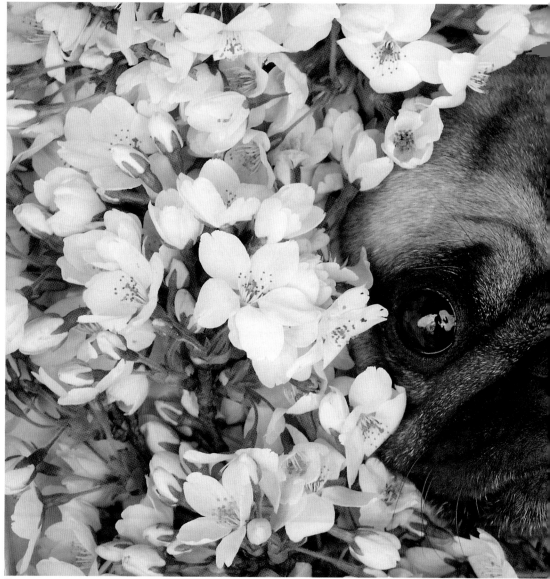

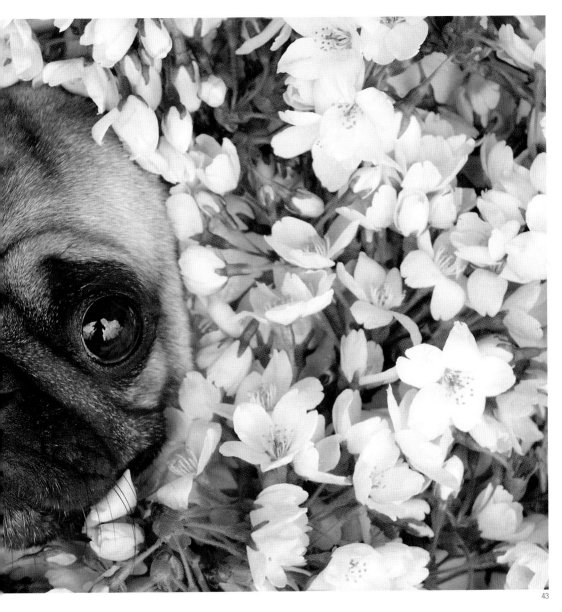

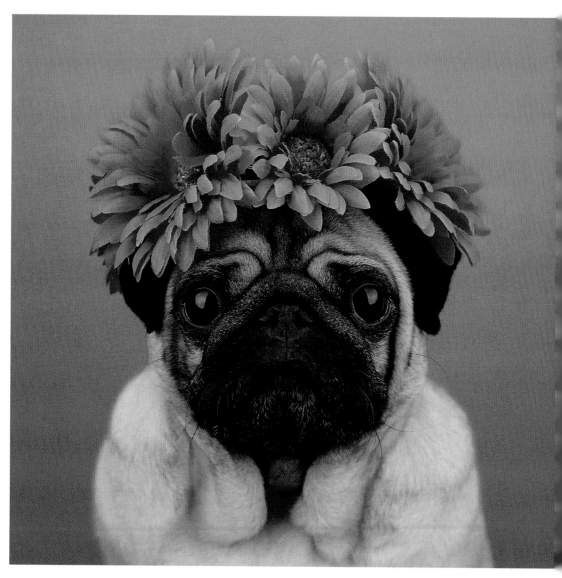

"Girls at music festivals be like…"

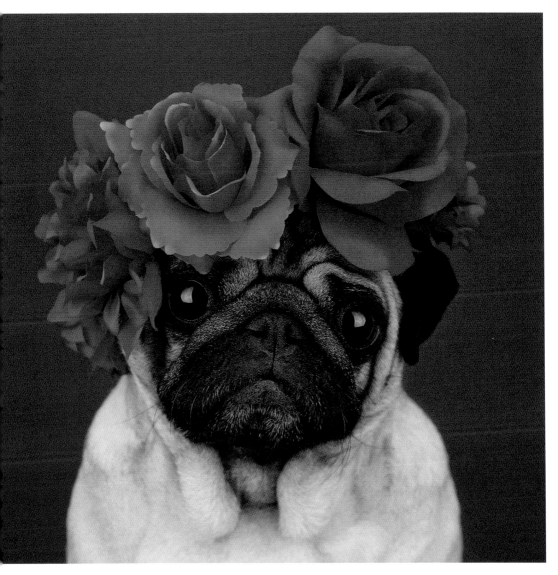

"Roses are red, grass is green. Gimme some food, if you know what I mean."

45

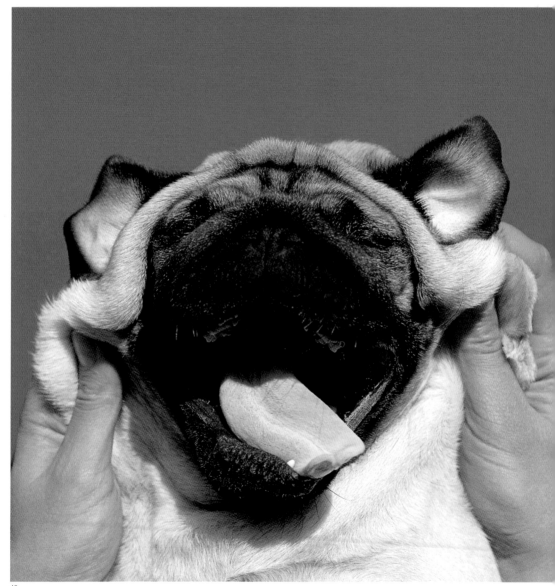

Chapter 6
SQUISH SQUISH

Squeeze my face and make a wish.

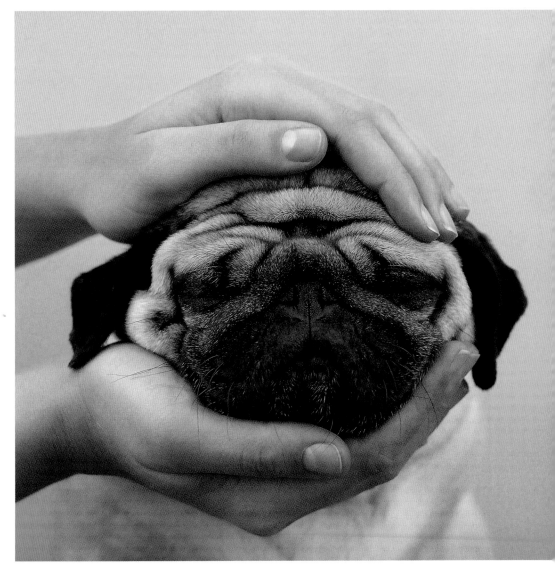

"Say squeeze!"

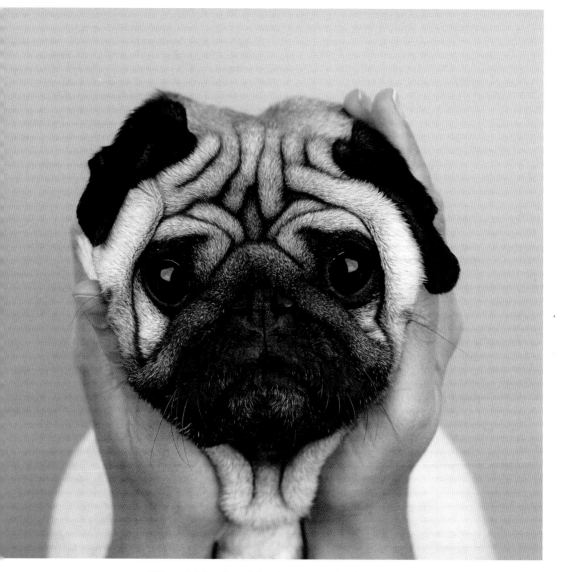

"The wrinklier the raisin, the sweeter the fruit."

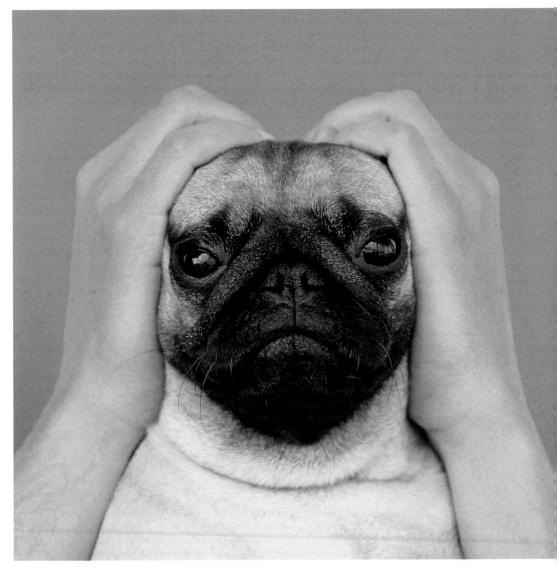

"Botox? Never heard of it."

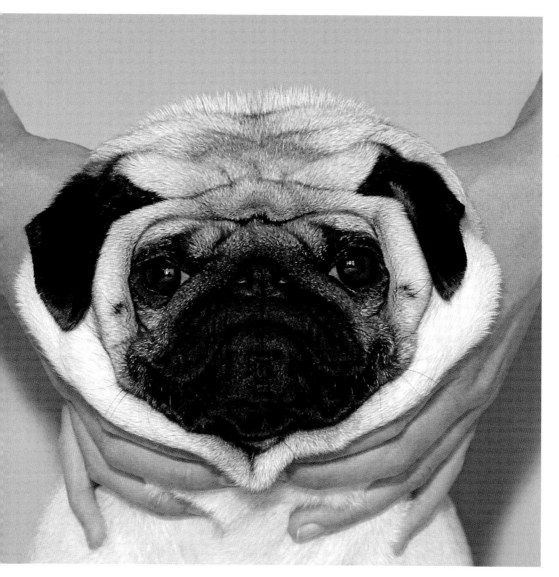

"So much for anti-wrinkle cream!"

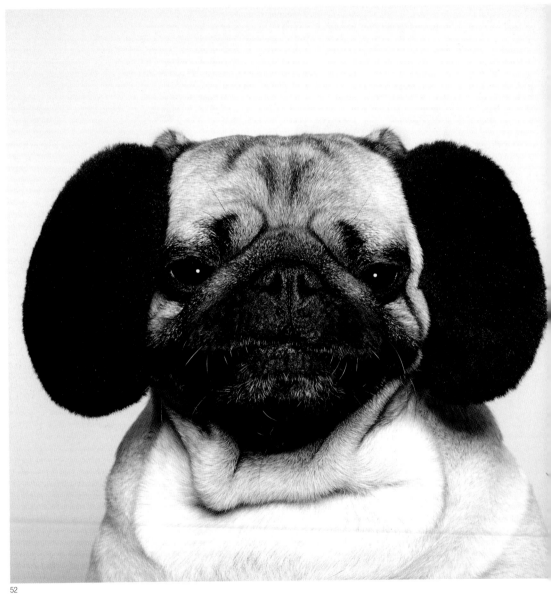

Chapter 7
MASTER OF DISGUISE

Always be yourself, or not.

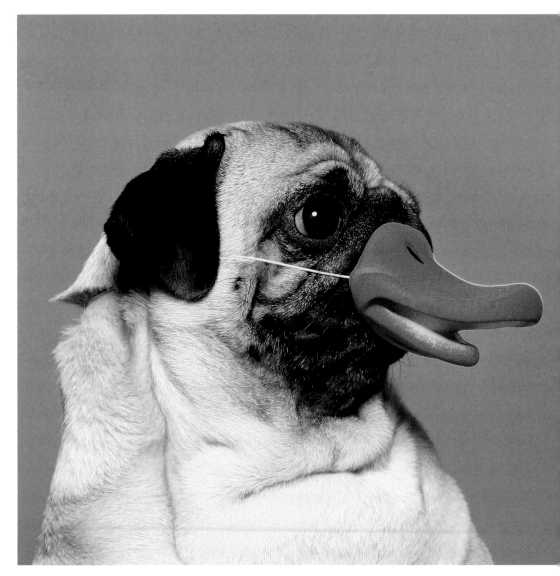

"Duck face meets pug face."

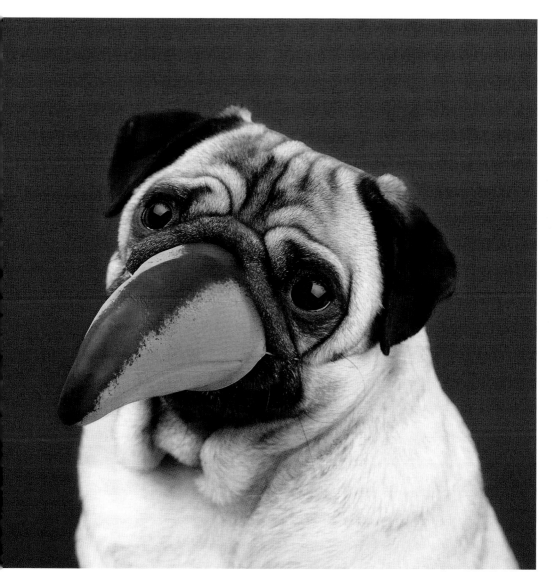

"Toucan do it."

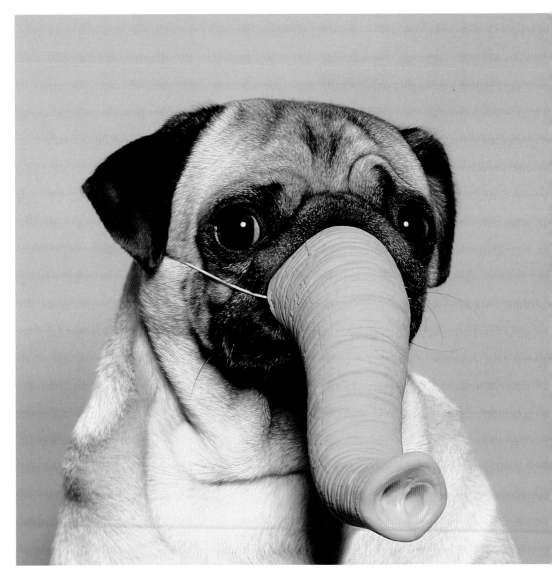

"Can we please talk about the elephant in the room?"

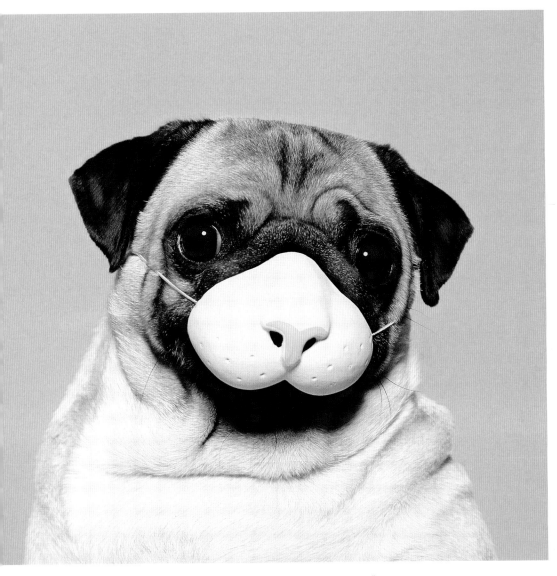

"You have cat to be kitten me right meow."

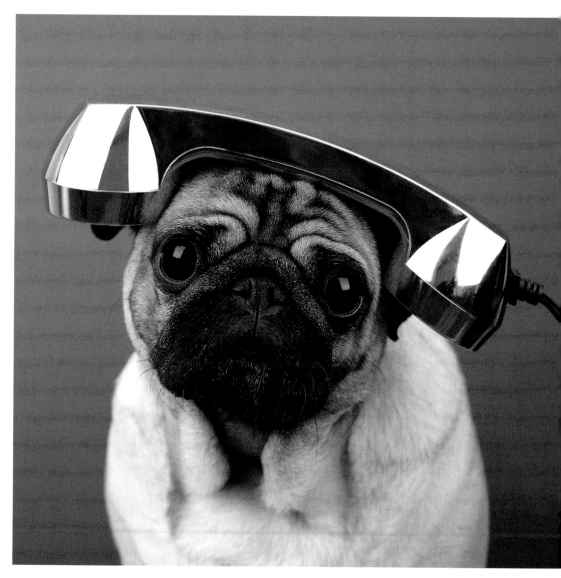

"Call me maybe?"

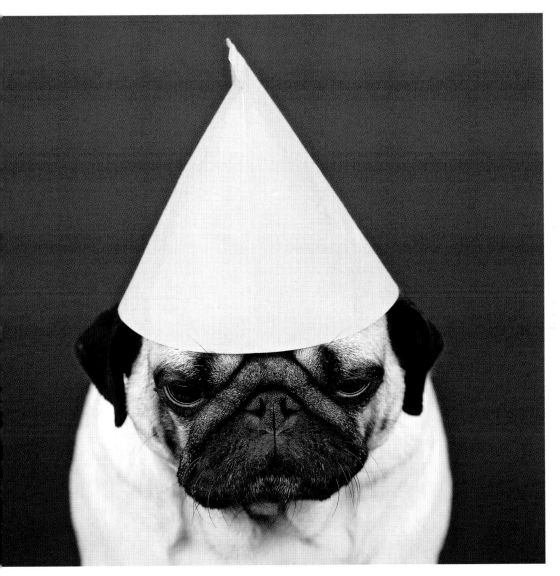

"This coffee is broken – I'm still tired."

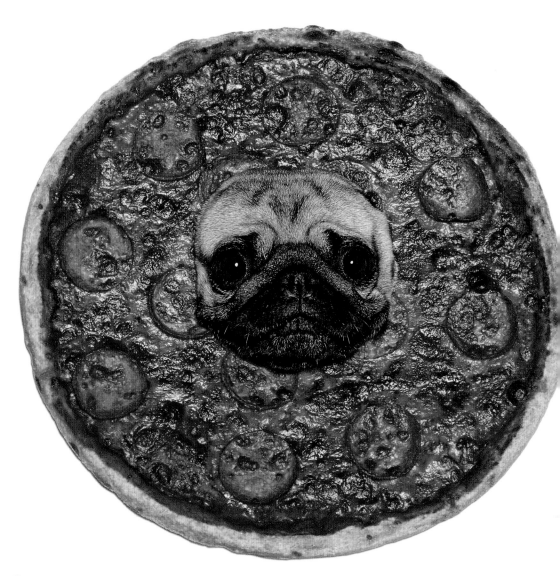

Chapter 8
<u>YUMMY</u>

All food is dog food.

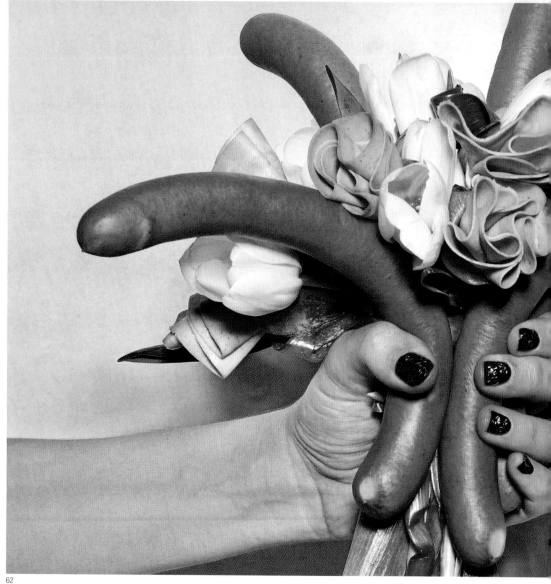

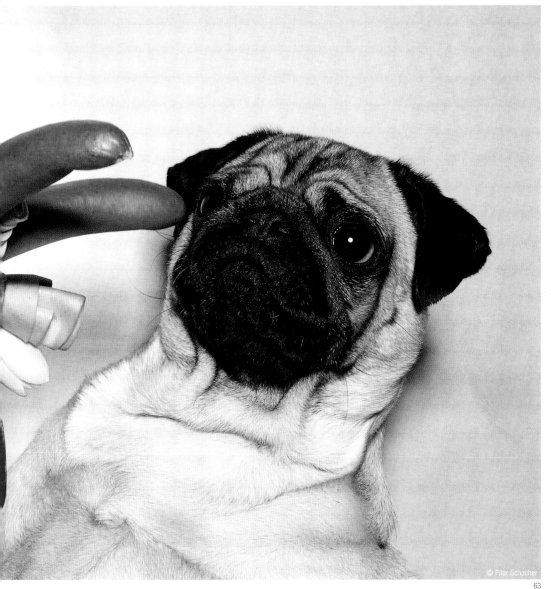

© Pilar Schacher

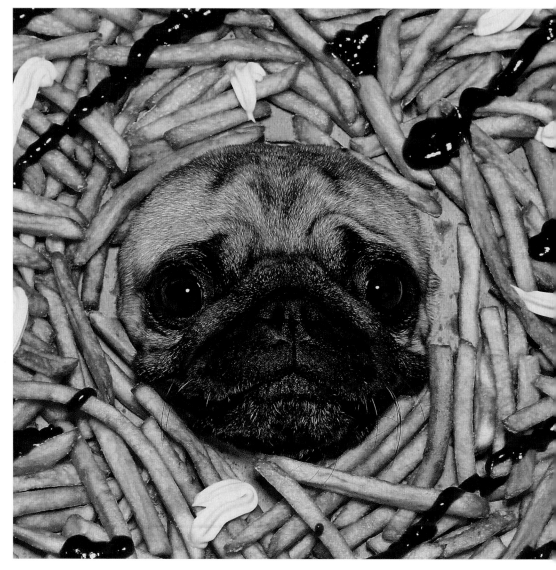

"Exercise? I thought you said extra fries!"

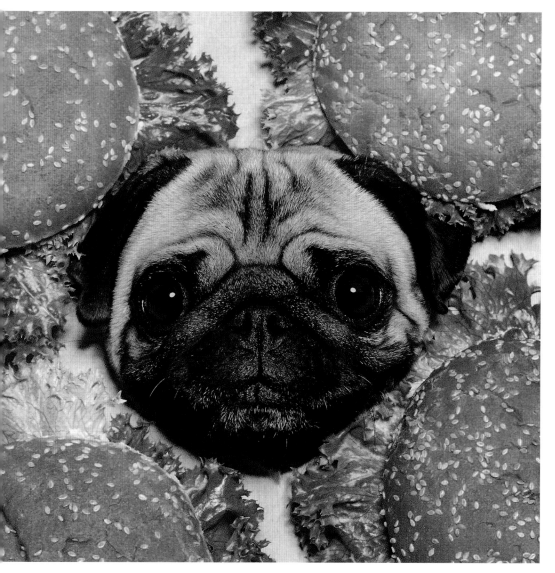

"Welcome to Burger Pug, may I take your order?"

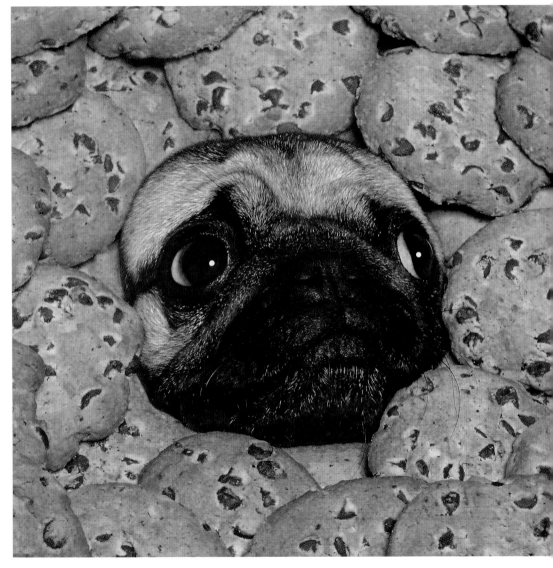

"I got 99 cookies 'cause you ate one."

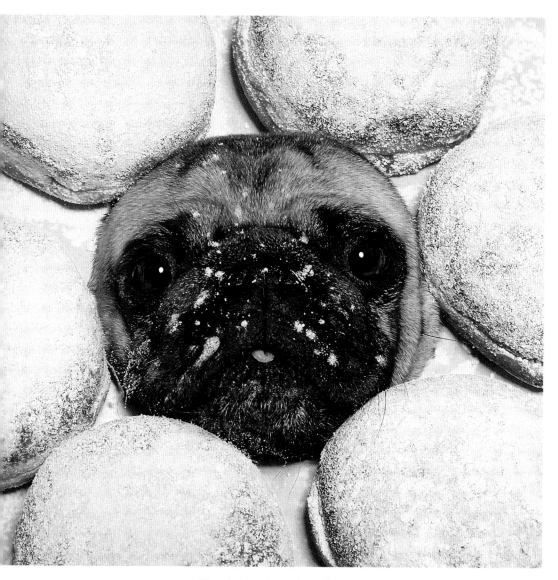

"Doughnut eat me please!"

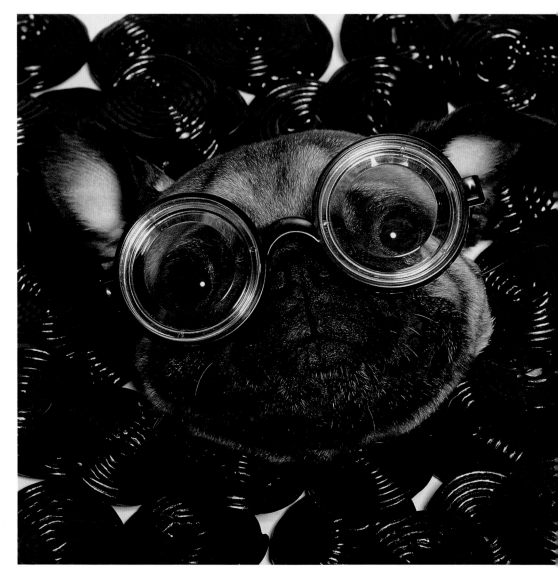

"This is how I roll."

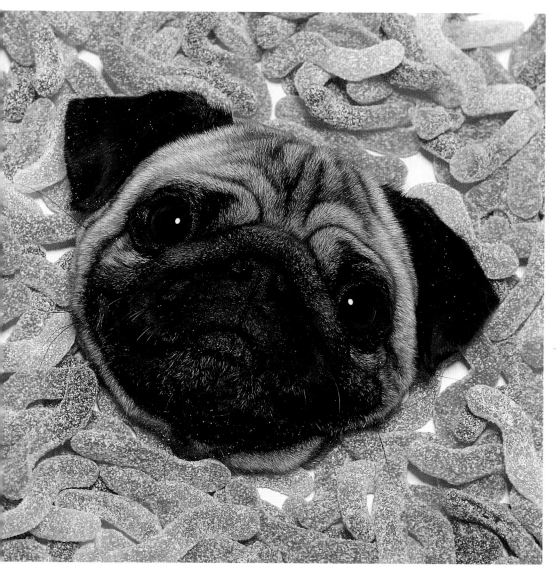

"Not sure if I'm refreshed and excited or just high on sugar."

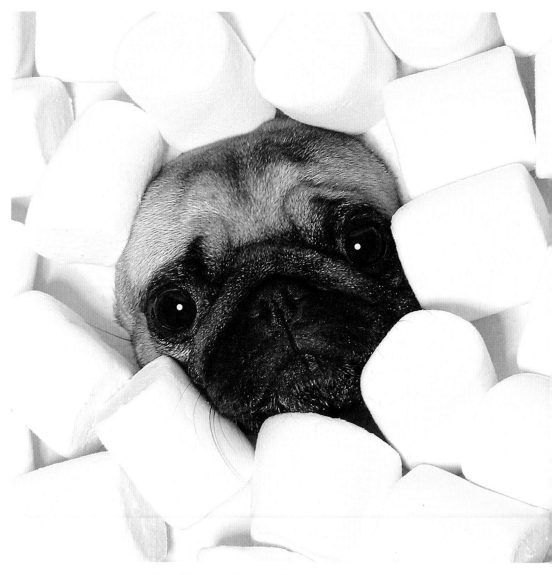

"Day 32 and my human still thinks I'm a marshmallow."

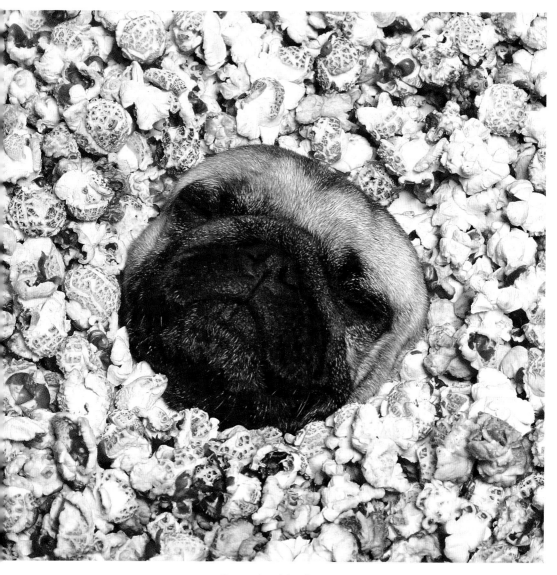

"I regret nothing."

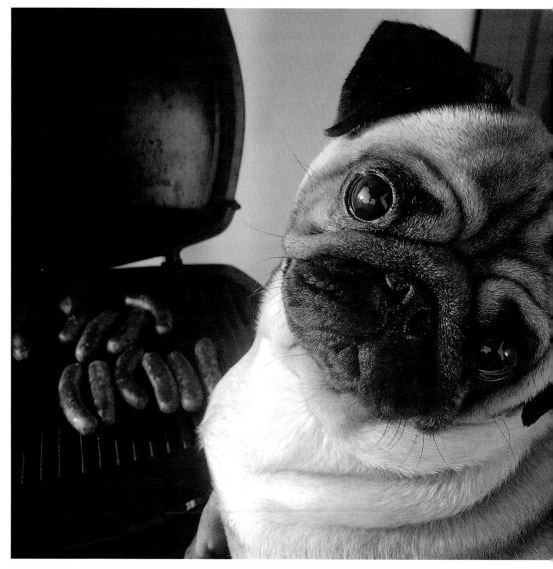

"Do you want yours licked or not licked? Just kidding, they're all licked."

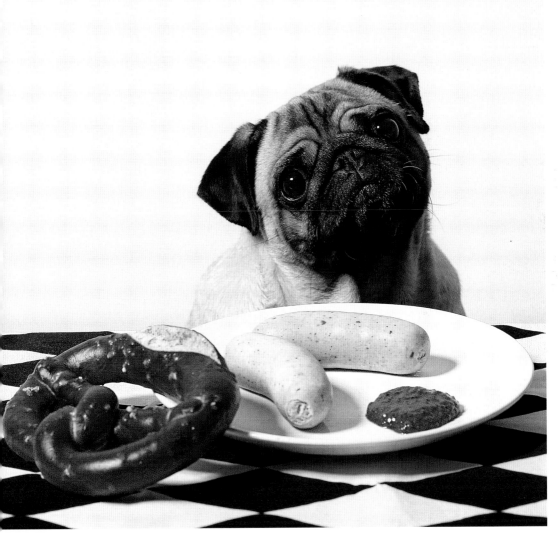

"Are you gonna eat those? I'm pretty sure I sneezed on them."

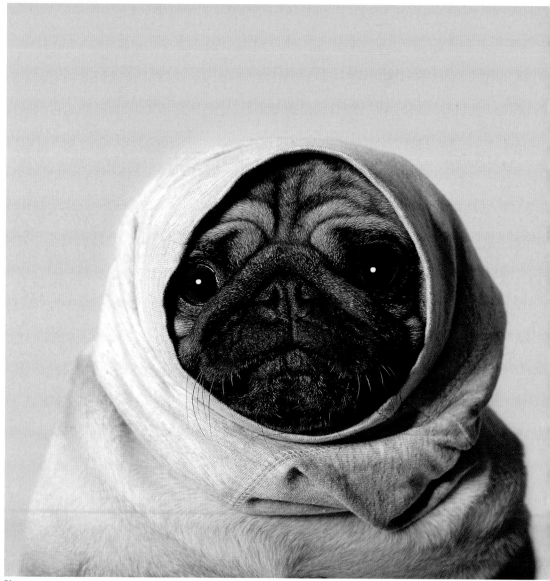

Chapter 9
<u>OUTFIT OF THE DAY</u>

It's called fashion, look it up.

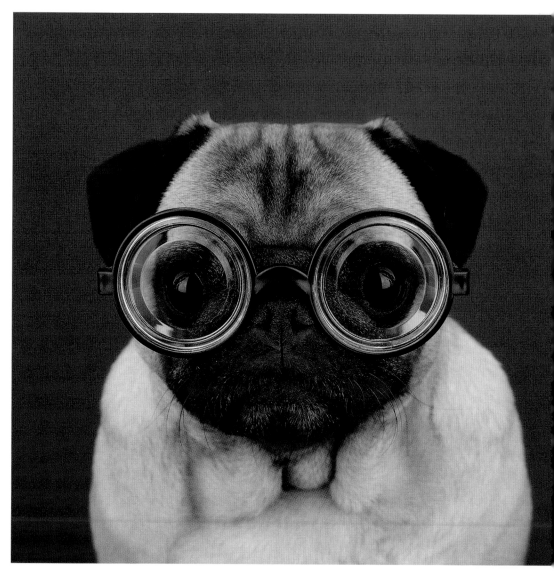

"If I wear nerd glasses, people will think I went to college."

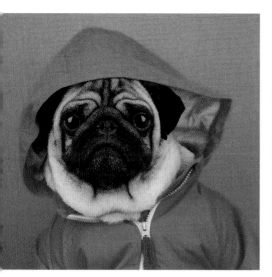
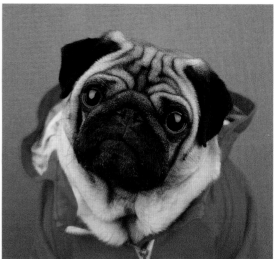
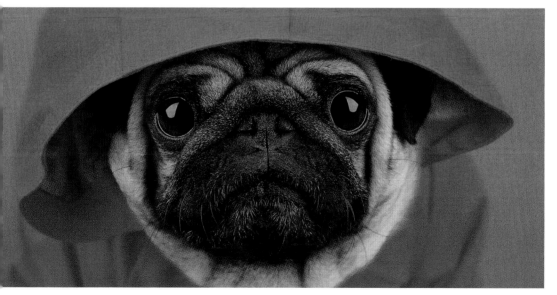

"You are sadly mistaken if you think this will convince me to go outside in the rain to pee."

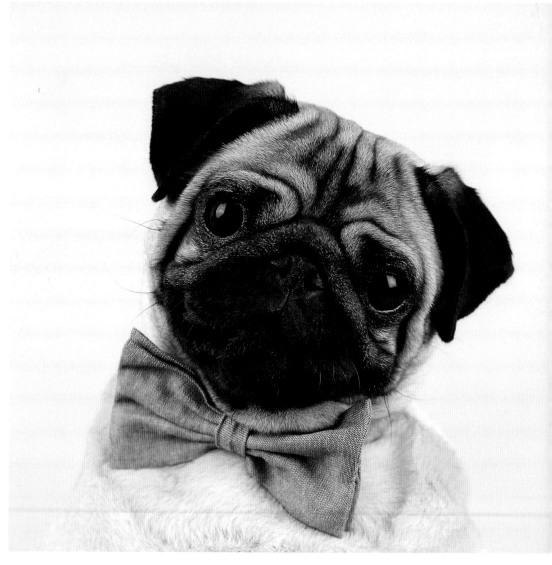

"So classy I don't need pants."

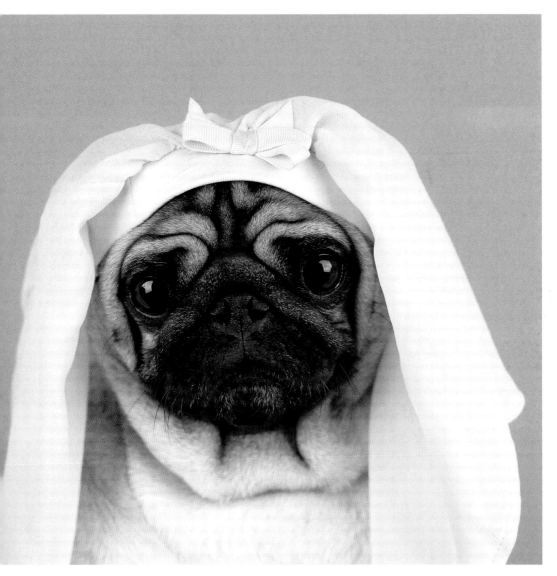

"What happens in Vegas stays in Vegas."

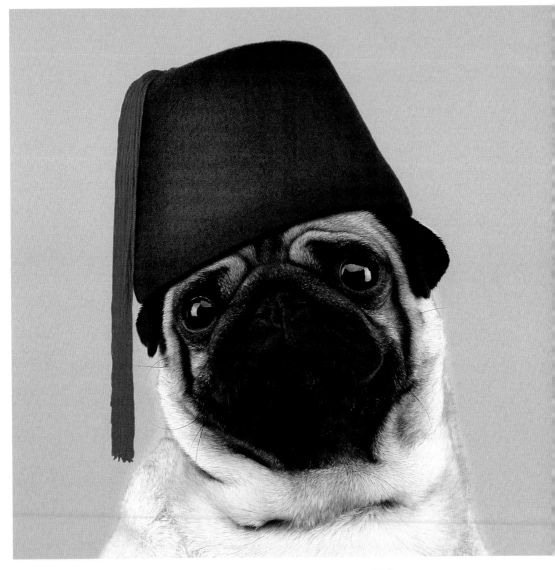

"I wear a fez – your argument is invalid."

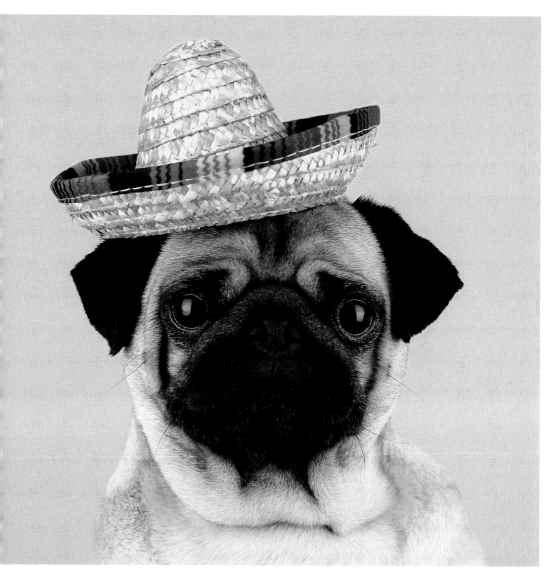

"Juan is the loneliest number."

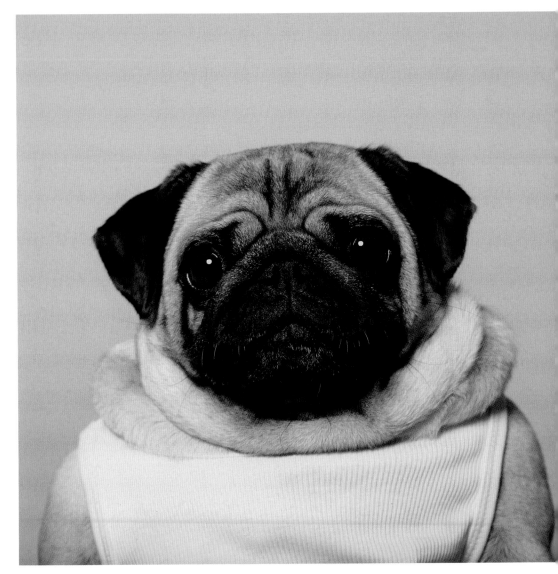

"Life's too short to be skinny."

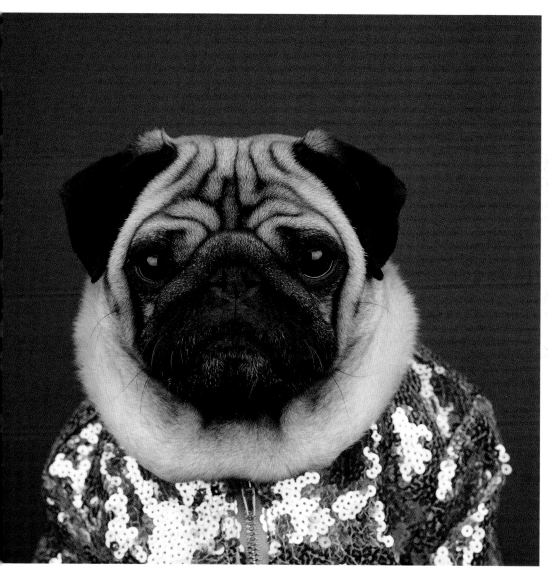

"Don't get why they call it a catwalk..."

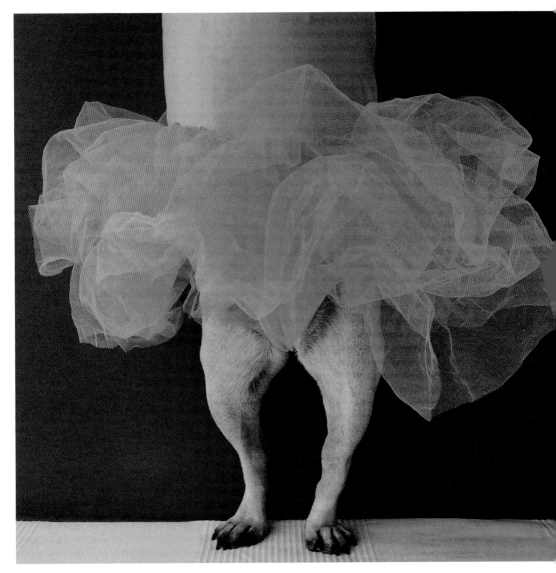

"Tutu fabulous for you."

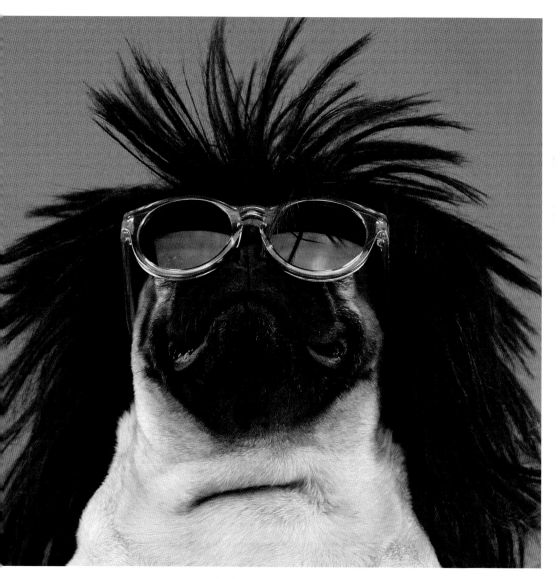

"Gettin' wiggy with it."

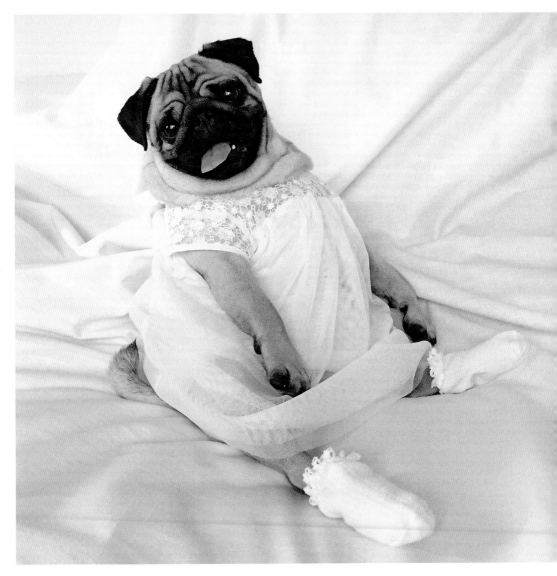

"You may call me princess."

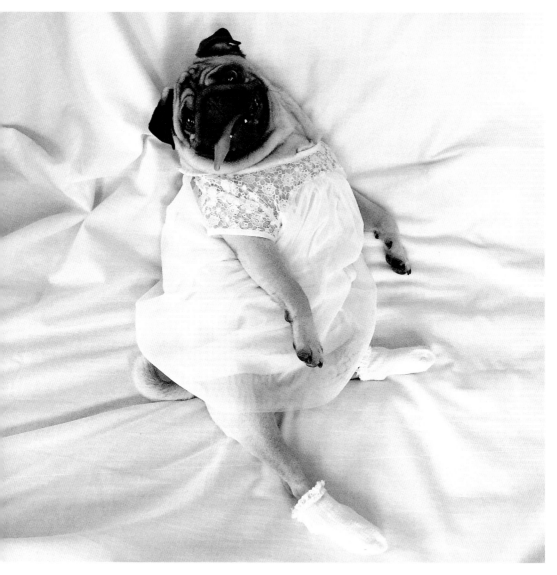

"Draw me like one of your French girls."

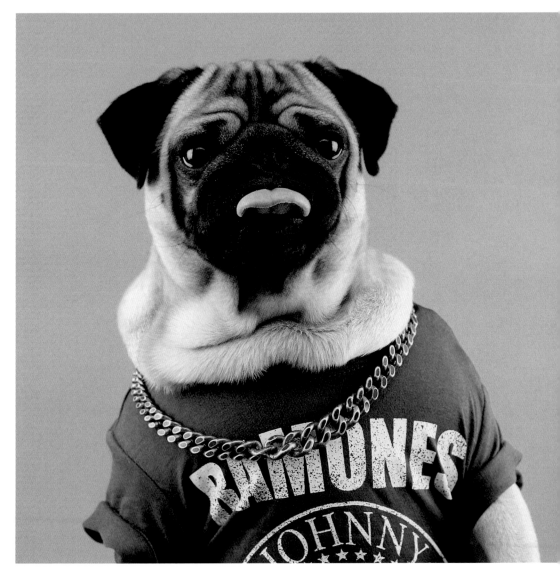

"Rap is like scissors – it always loses to rock."

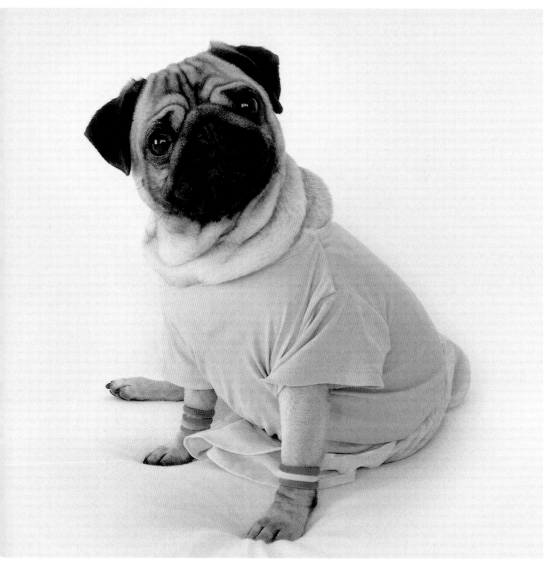

"When your personal trainer asks you how you're feeling during your workout."

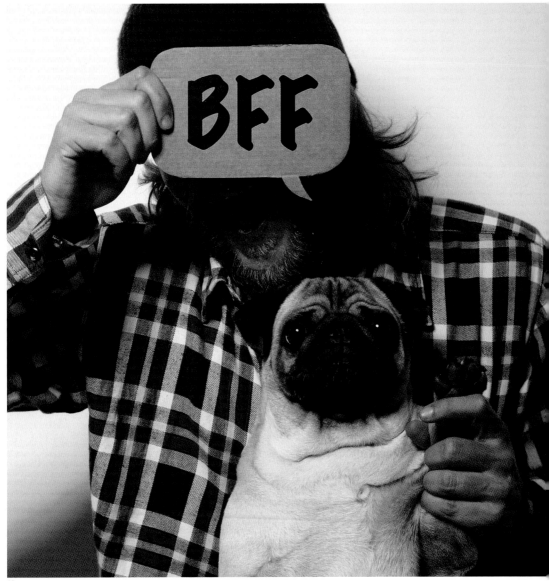

Chapter 10
BEST FRIENDS

Just call my name and I'll be there.

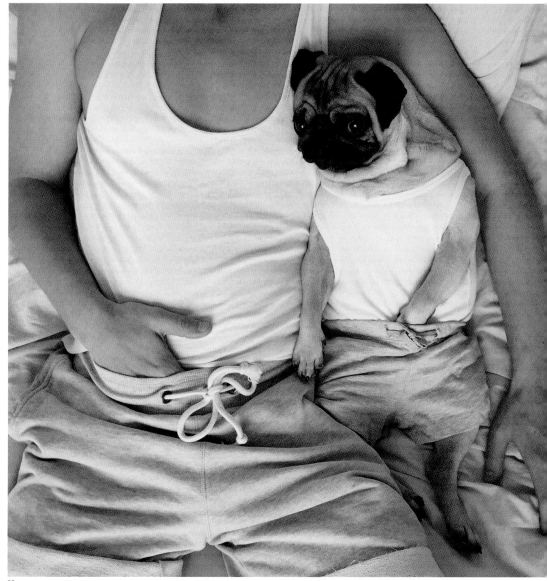

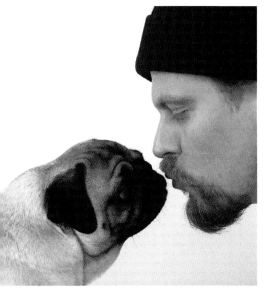
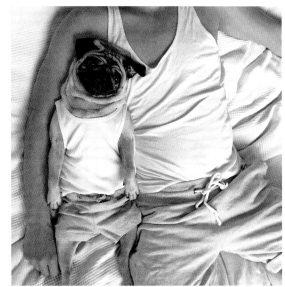
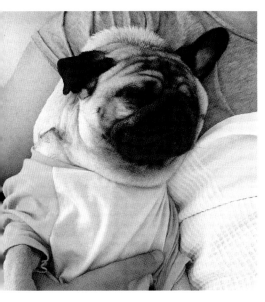
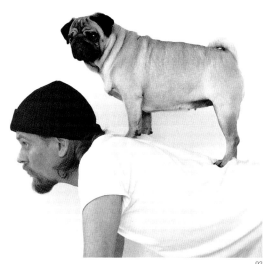

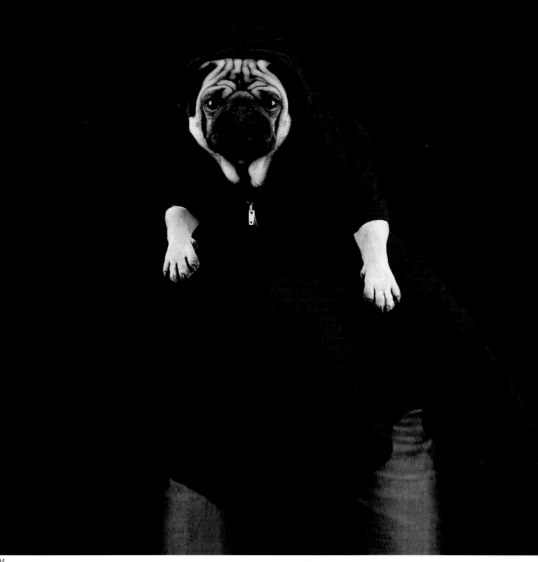

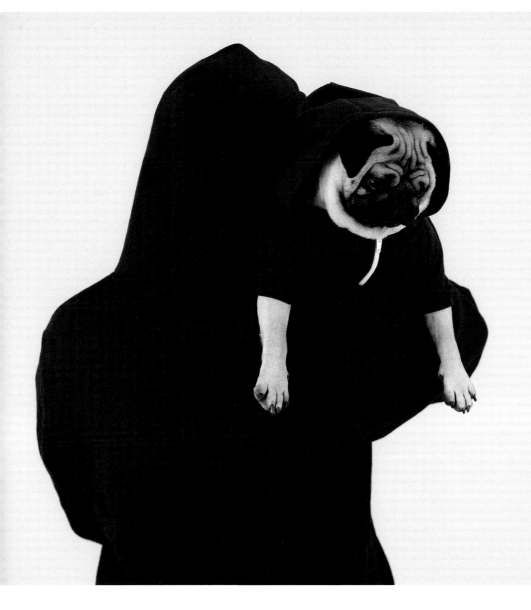

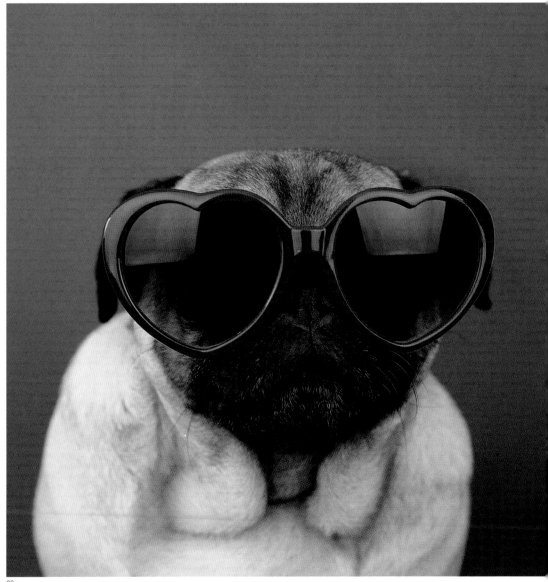

Chapter II
SUNGLASSES

Excuse me while I look fabulous.

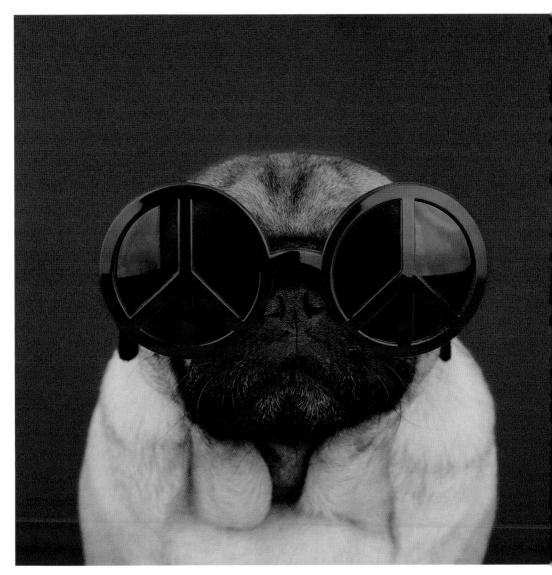

"No war, just peace 'n' stuff."

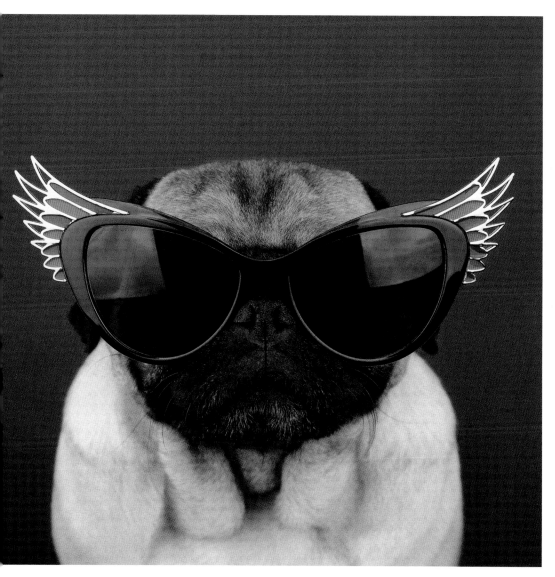

"I am who I am – your approval is not needed."

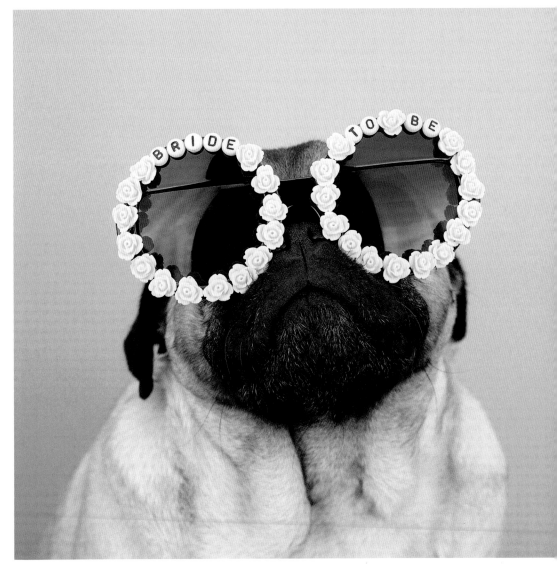

"If you liked it then you shoulda put a ring on it."

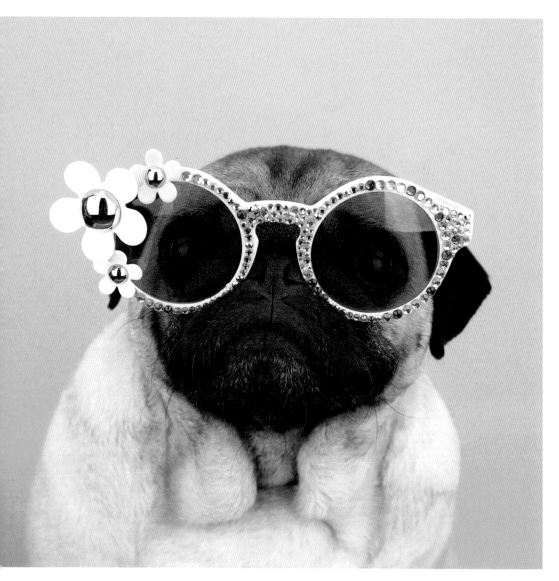

"No one's life is perfect, but mine is pretty close."

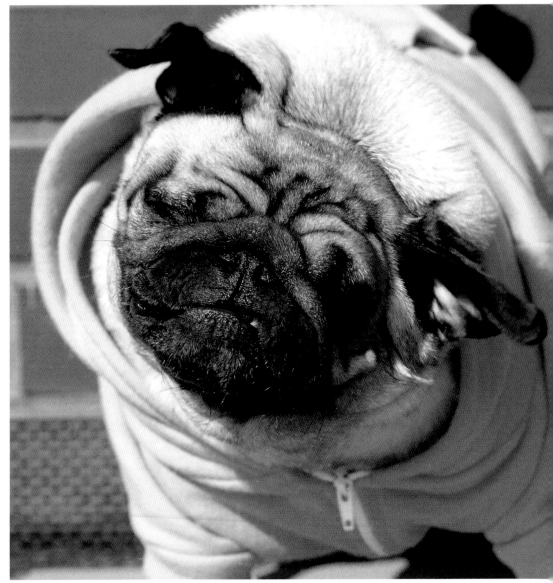

Chapter 12
<u>SHAKE IT OFF</u>

Haters gonna hate.

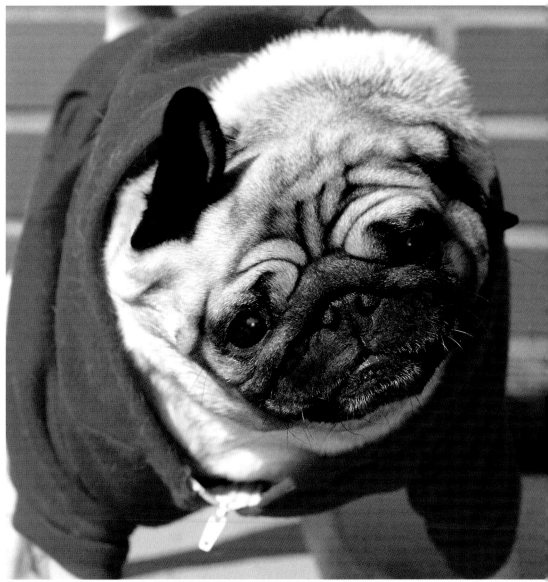

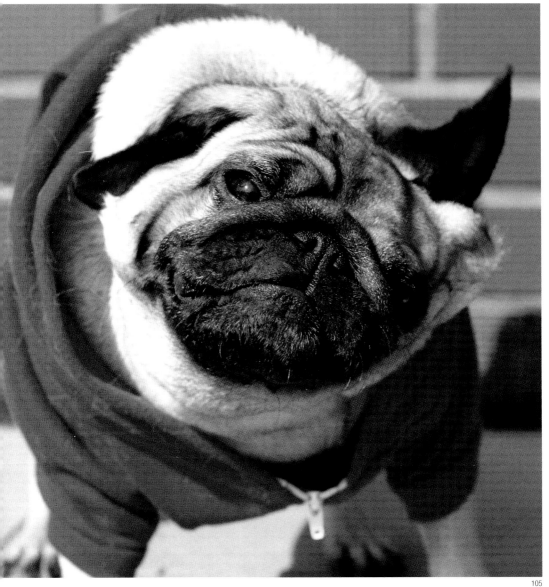

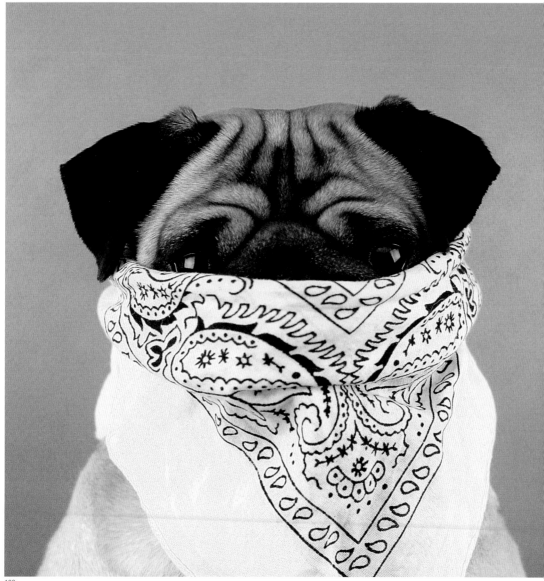

Chapter 13
PUG LIFE

Life as a pug ain't easy.

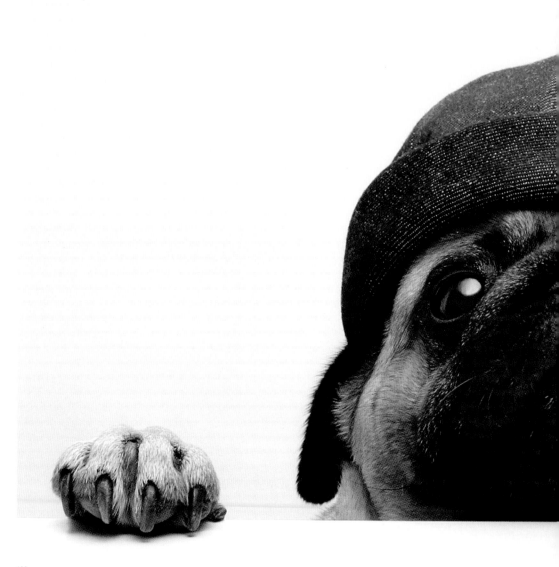

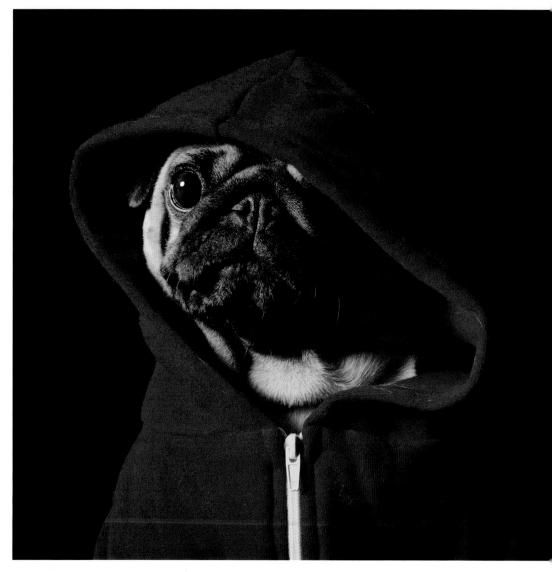

"I didn't choose the pug life, the pug life chose me."

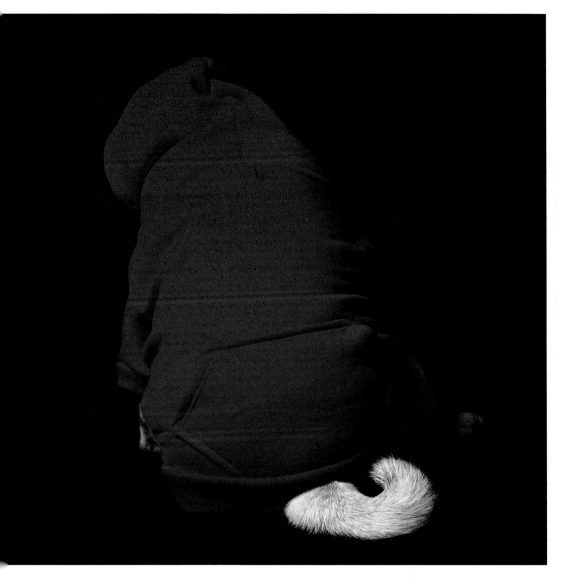

"Yeah, if someone could rub my back, that'd be great."

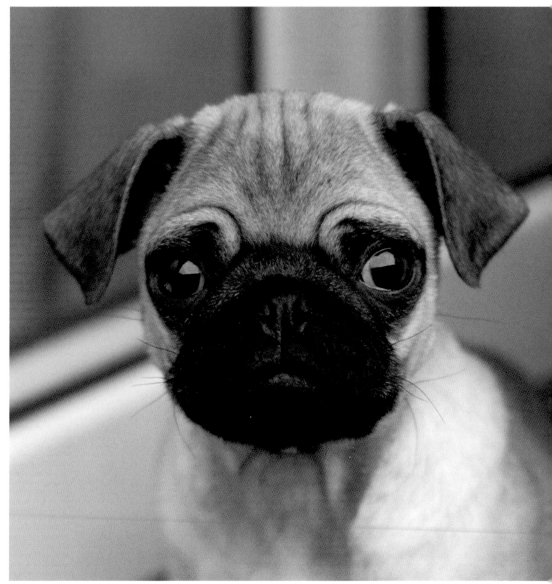

Chapter 14
THROWBACK

To the good times that I've wasted having good times.

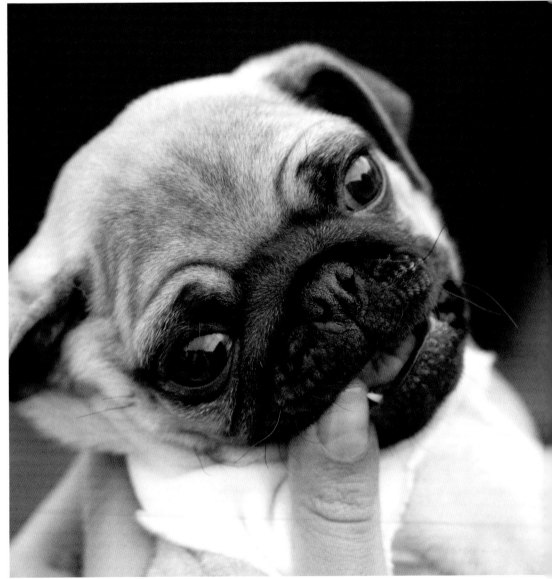

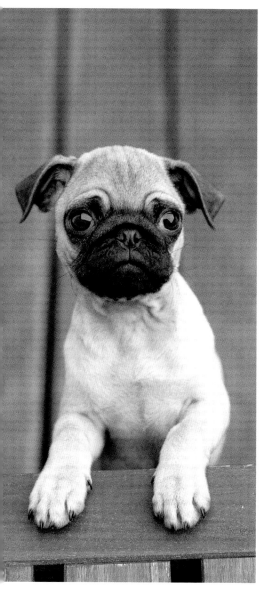
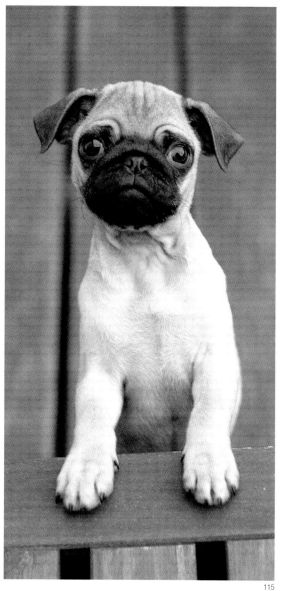

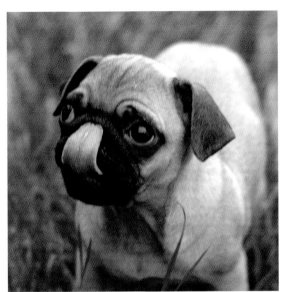
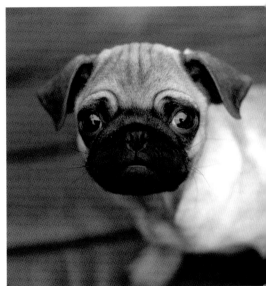
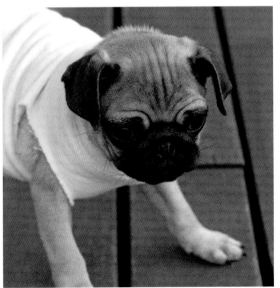
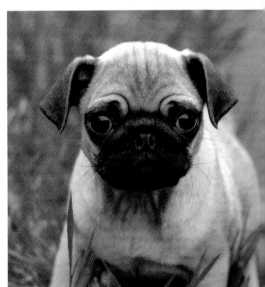

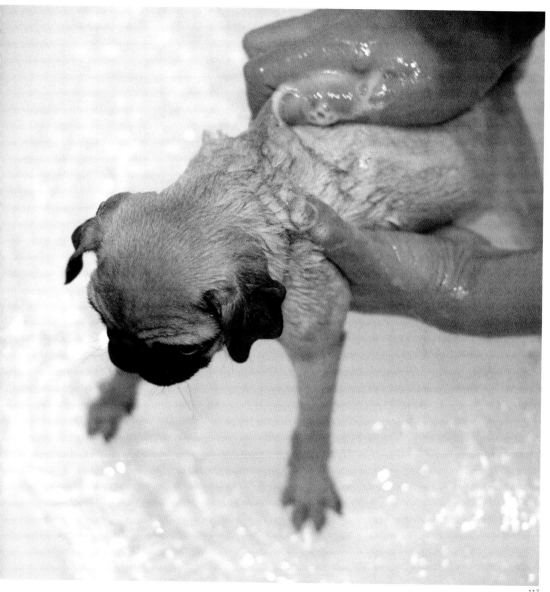

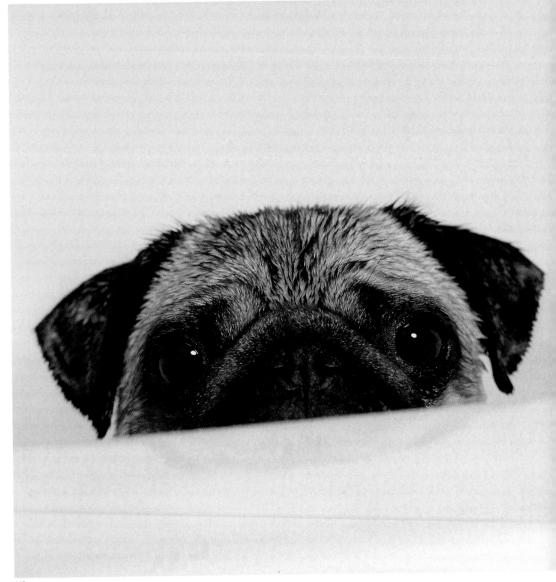

TO BE
CONTINUED...

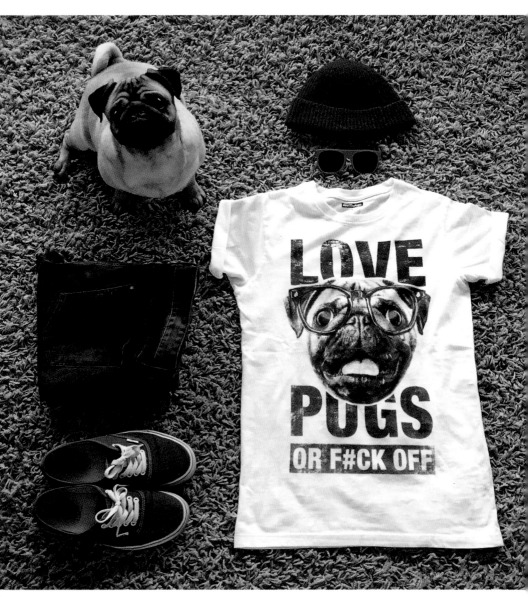

MEET THE PUGS

Meet The Pugs is more than just cute pictures. Indeed, the original idea behind this name was the development of an animated sitcom about the everyday adventures of half-human half-pug characters.

In order to gather facial expression references for the characters, Markus started taking pictures of Loulou. The pictures quickly became hugely popular on Instagram and the account hasn't stopped growing since.

Loulou is now the official face of the brand Meet The Pugs. Beyond the constant production of new pictures, a whole range of merchandise has been created to satisfy the fans' demands: calendars, greeting cards, T-shirts, art prints and much more! To see more, go to:

www.meetthepugs.com

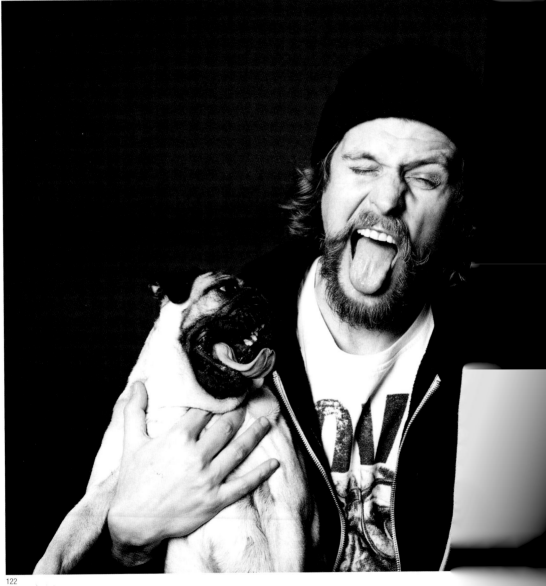

LOULOU

Loulou is a four-year-old pug born in Spain, where she got adopted in 2012 by Markus and Yasmina. The whole family moved to Berlin, Germany in 2014. Loulou's passions are eating, sleeping, snoring, sneezing on other people's food, more eating, playing with fluffy toys, more sleeping, chasing skateboarders, birds and planes, barking at dogs on TV, chilling in the sun and racing with Markus. Her biggest dream is a never-ending salami pizza.

MARKUS

Markus Müller is the Creative Director and Photographer behind Meet The Pugs and Loulou's best friend. He and Yasmina Abdelilah, Loulou's proud mama, spend their days coming up with new picture ideas and managing Loulou's busy schedule — not easy when your model needs at least 20 hours of beauty sleep a day!

ACKNOWLEDGEMENTS

First of all, thanks to Loulou for her patience during all these photo shoots and for being a never-ending source of love and inspiration; Kate Pollard and all at Hardie Grant UK; all of Loulou's fans across the world for their unconditional love; Pilar Schacher for that crazy sausage picture and the beautiful sprinkles composition; Sylvain for his great ear and eye; Victor for his incredible animation skills; Monika, Klaus, Tina, Max, Vera, Barbara, Mustapha, Schéhérazade, Olympia, Amir-Alexander, Hélène, Antonia, Anselm, Maria, Susi, Peter, Torben & Lotte, Nicole & Elvis for their support since the very beginning of this adventure.

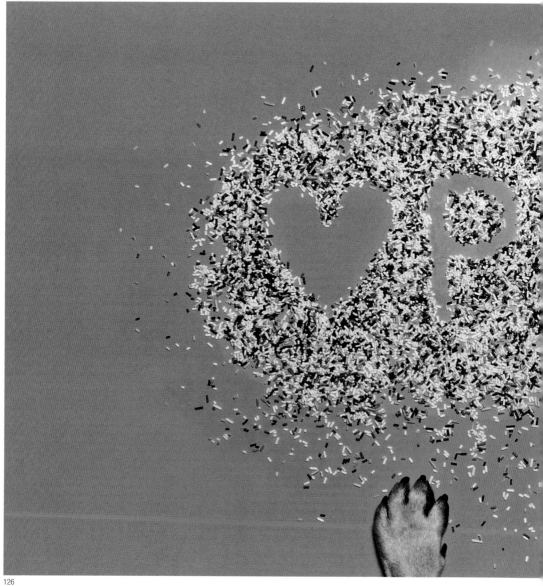

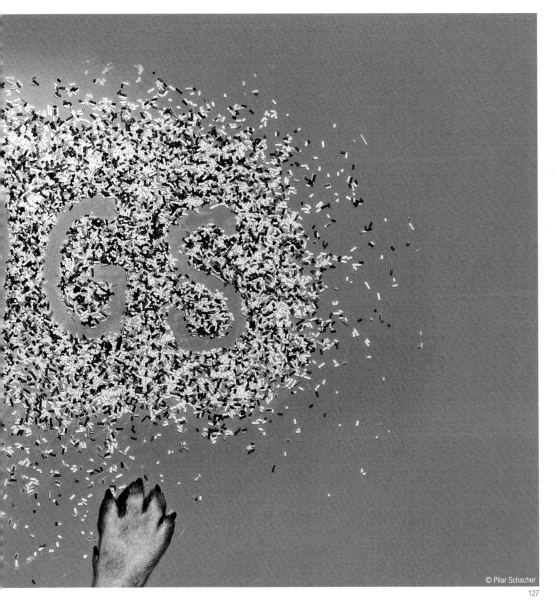

127

Loulou The Pug by Markus Müller and Yasmina Abdelilah

First published in 2016 by Hardie Grant Books

Hardie Grant Books (UK)
5th & 6th Floor
52-54 Southwark Street
London SE1 1UN
hardiegrant.co.uk

Hardie Grant Books (Australia)
Ground Floor, Building 1
658 Church Street
Melbourne, VIC 3121
hardiegrant.com.au

British Library Cataloguing-in-Publication Data. A catalogue record
for this book is available from the British Library.

ISBN: 978-1-78488-077-4

Publisher: Kate Pollard
Senior Editor: Kajal Mistry
Editorial Assistant: Hannah Roberts
Photography: Markus Müller
Art Direction: Markus Müller
Colour Reproduction by p2d

Printed and bound in China by 1010

10 9 8 7 6 5 4 3 2 1